MASTER COLLECTION

HOWL

Illustrated by Katy Lipscomb

Blue Star
PREMIERE

Blue Star™

Blue Star Coloring Books is in San Antonio, TX and Portland, OR.

Teamwork makes the dream work: This book was illustrated by Katy, designed by Chris,
written by Gabe and published by Camden. Adult Coloring Book, Stress Relieving Patterns,
Master Collection and Blue Star are trademarks of PCG Publishing Group, LLC.

Printed in the United States of America.

We Love What You Create and We Want to Shout It from the Rooftops

..

@bluestarcoloring #bluestarcoloring

..

Show Us Your Art We'll Show the World

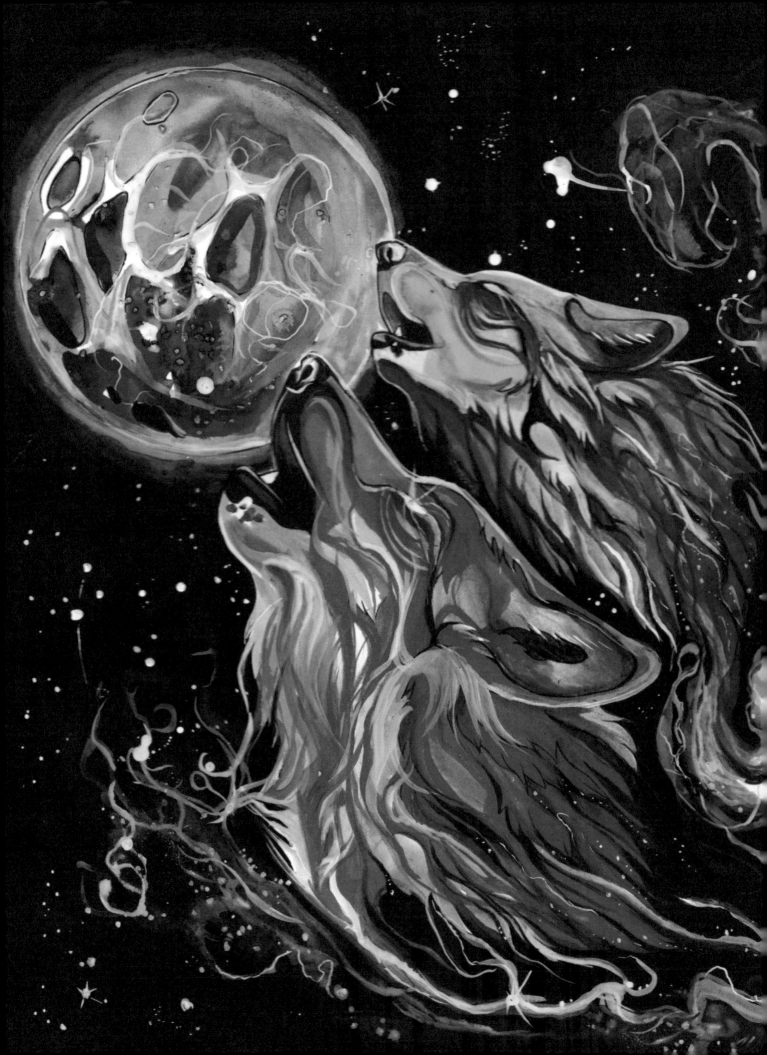

The Master Collection is an elite series of adult coloring book titles created for Blue Star by fine artists and high-profile illustrators across the globe. Each title is painstakingly illustrated, curated, designed and edited to meet uncompromising aesthetic standards. We believe that the Master Collection is the finest series of premium adult coloring books in the world — and we hope you'll agree.

Please send questions, comments and any other correspondence to contact@bluestarcoloring.com.

TIPS FROM THE ARTIST

"When coloring with colored pencils, I like to use a technique called burnishing. It is one of my favorite ways to blend two colors together. To achieve a burnished effect, place one color down in the area that you would like to color. Next, take another color (usually a lighter color) and push very hard over the bottom layer of color. You will see the two layers blend together and create a very smooth finish. For best results, it is better to put a lot of color or multiple layers down before adding the final burnished layer. Once the layer is burnished it can be frustrating to try to add color over top."

COLORED PENCILS

Wax-based pencils have incredible color and vibrancy. Because the lead is soft, it provides effortless transfer of colors and blending, although it is also prone to break easily. Be gentle with your wax-based pencils, and sharpen them carefully.

Hard lead pencils can also deliver rich colors, and are easier to sharpen. They are great for fine detail work, but they don't blend as well as a wax-based pencil.

MARKERS

Alcohol-based markers provide a one-of-a-kind experience. The alcohol prevents the markers from bleeding when water or other colors are added. They are often rich in color, and with proper practice, will blend nicely.

Water-based markers bleed when water is added, and blend effortlessly when one color is used over another. They provide a great blending and color-mixing experience.

ANALOGOUS COLORS

Analogous colors are next to each other on the color wheel, so they always work nicely with one another. One example of a set of analogous colors is violet, red-violet and red.

MONOCHROMATIC COLORS

Monochromatic colors are variations on one specific color. You can add white to a color to make a tint, and add black to make a shade. By using these techniques, you can create an infinite amount of variations.

COMPLEMENTARY COLORS

Complementary colors are opposite from each other by providing contrast. Complementary color combinations include red/green, blue/orange and yellow/purple.

HOWL

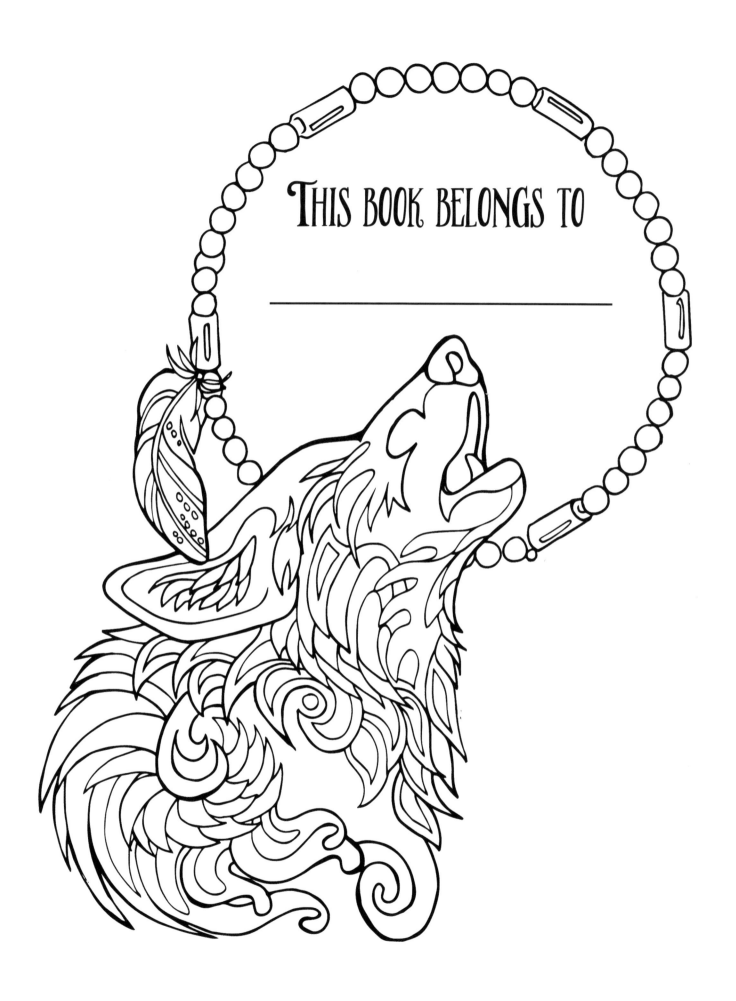

THIS BOOK BELONGS TO

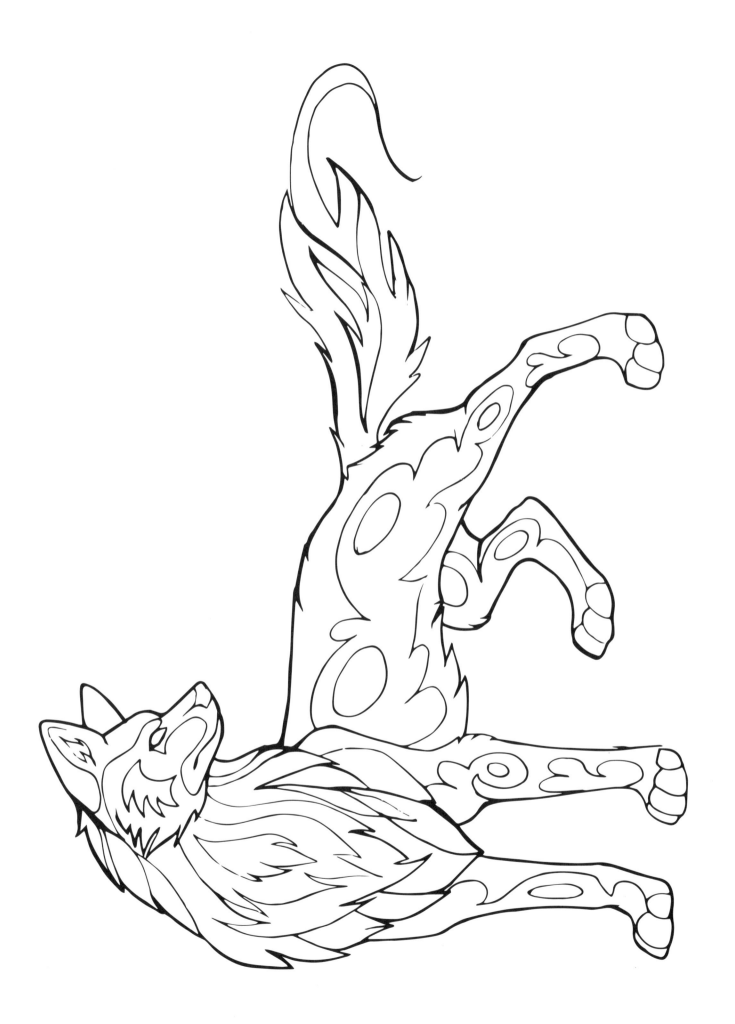

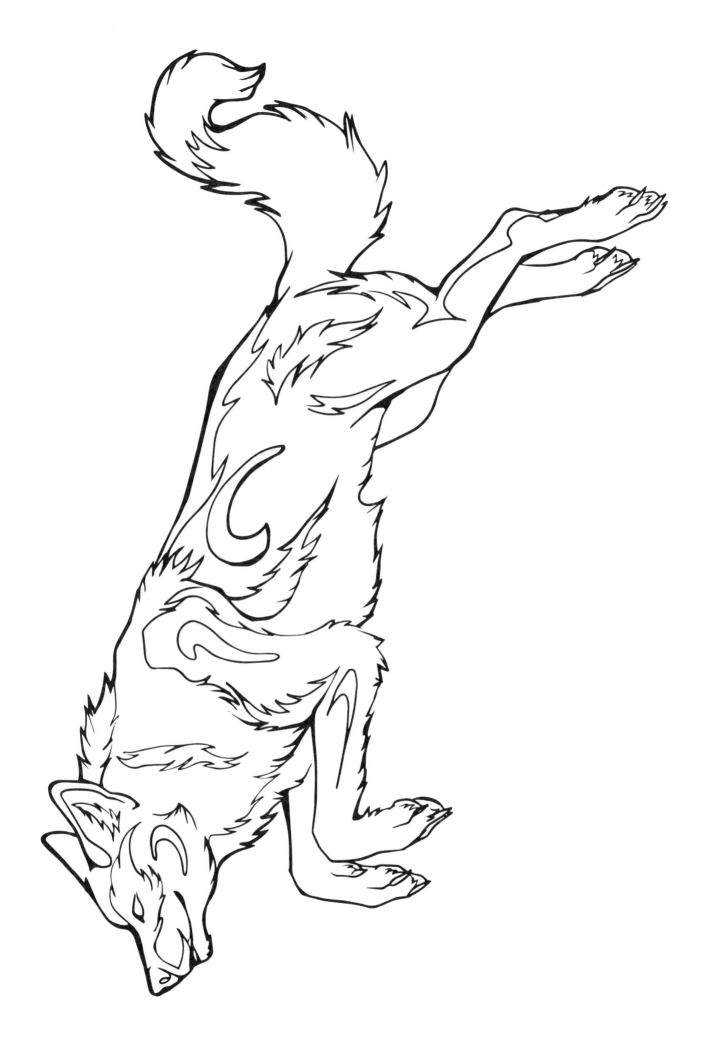

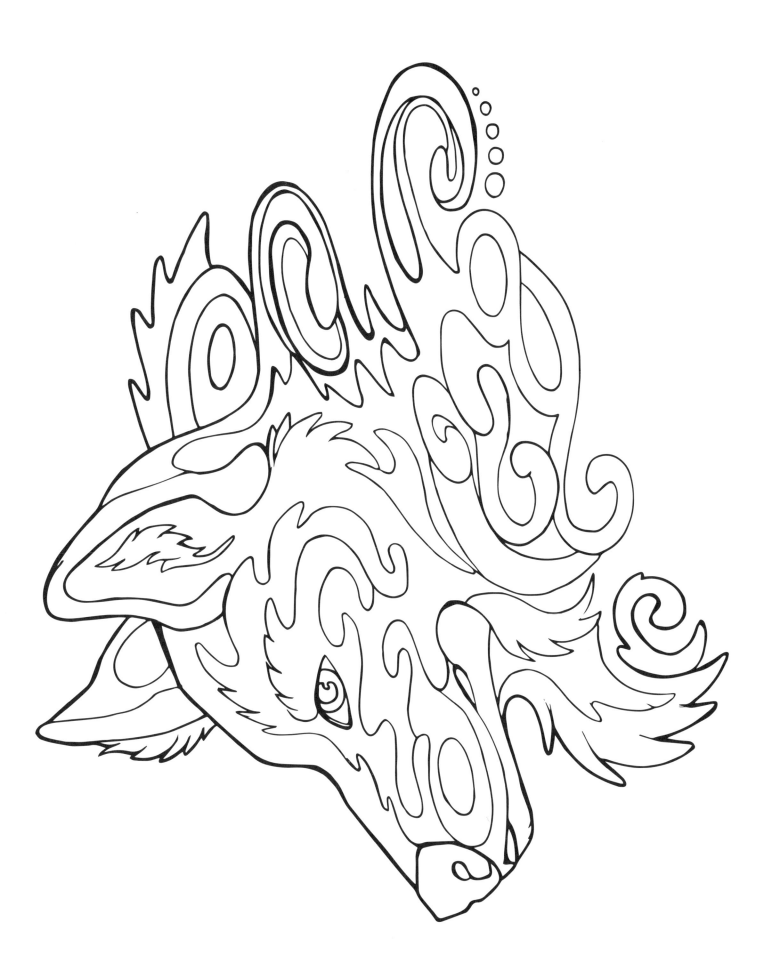

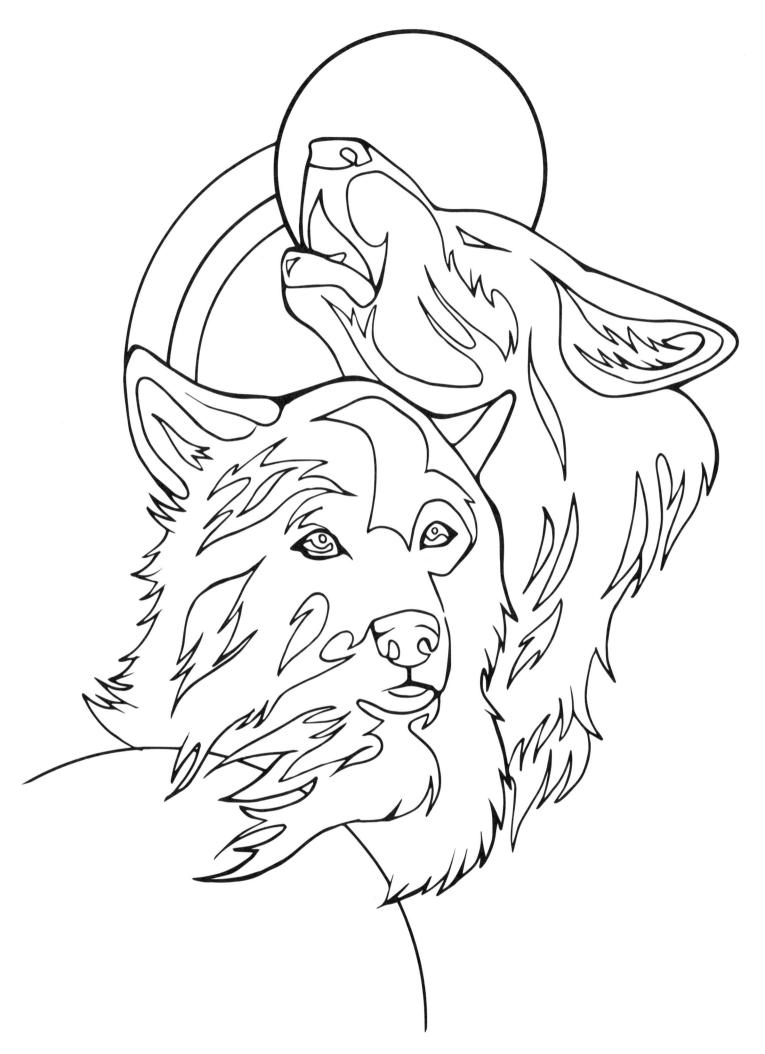

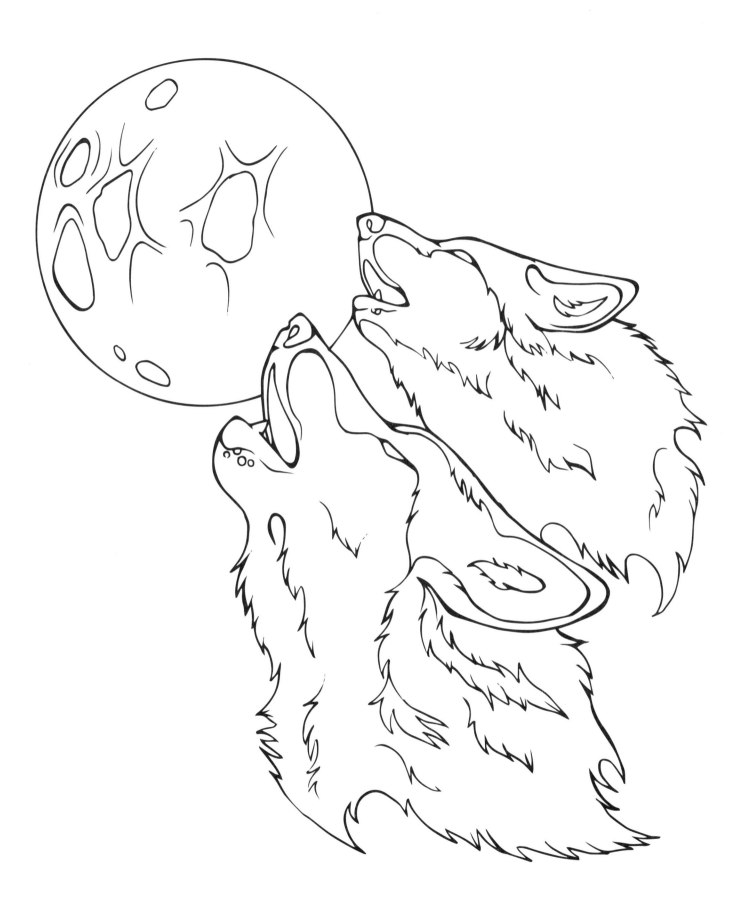

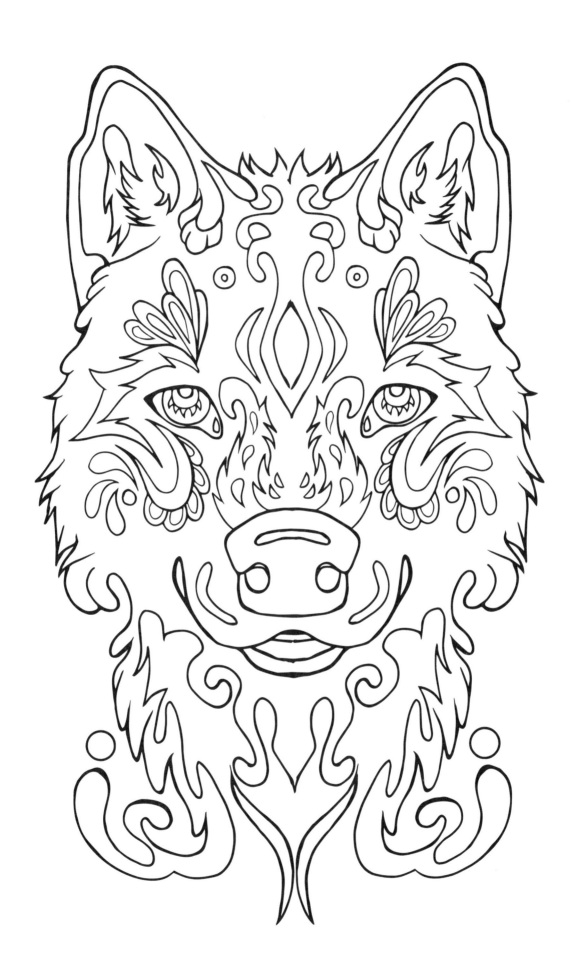

For the strength of the Pack is the Wolf,
and the strength of the Wolf is the Pack.

RUDYARD KIPLING

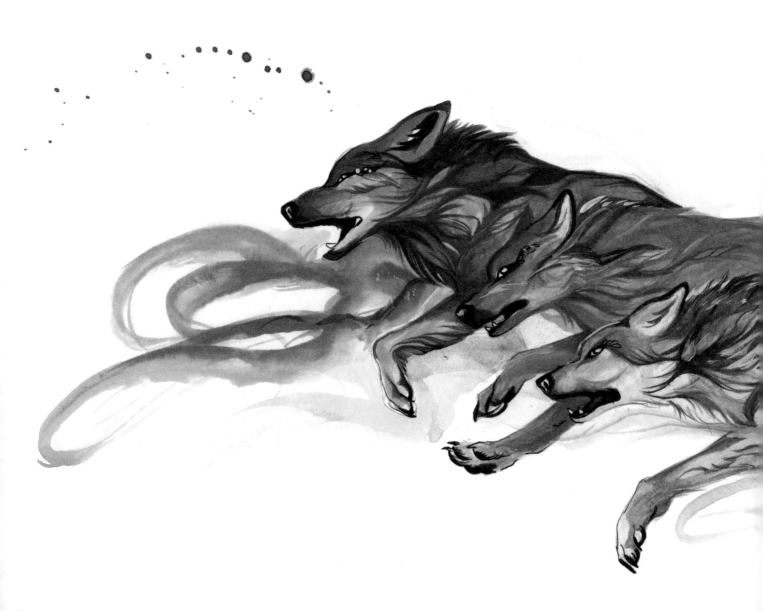

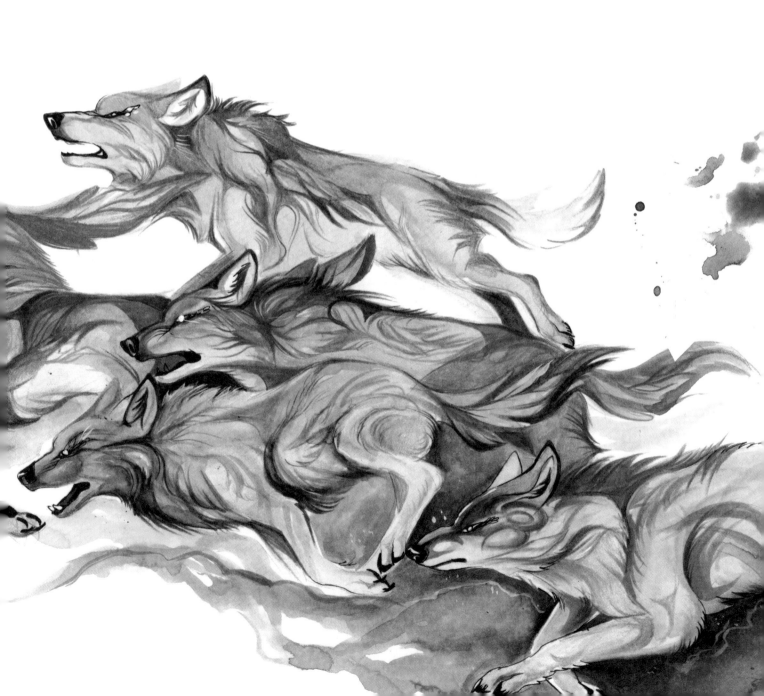

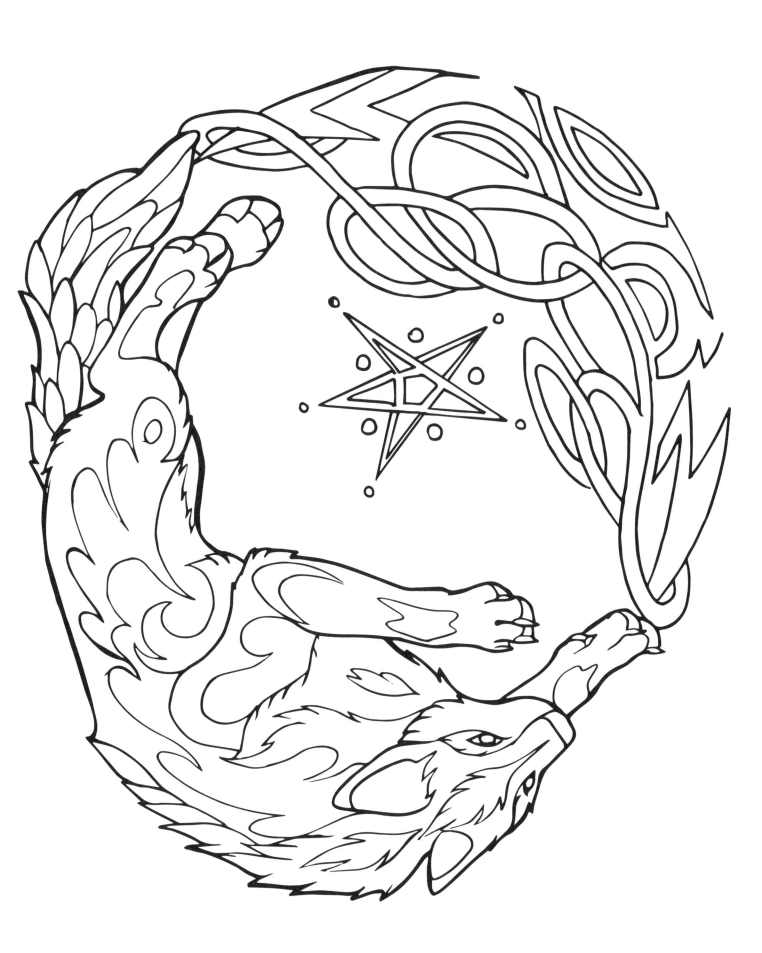

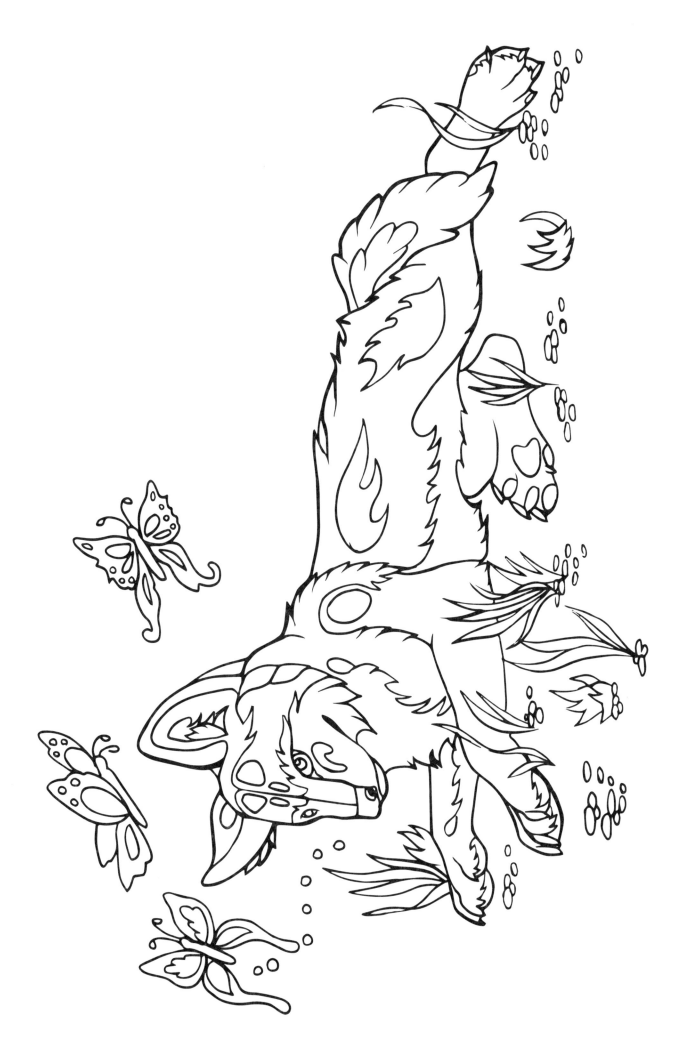

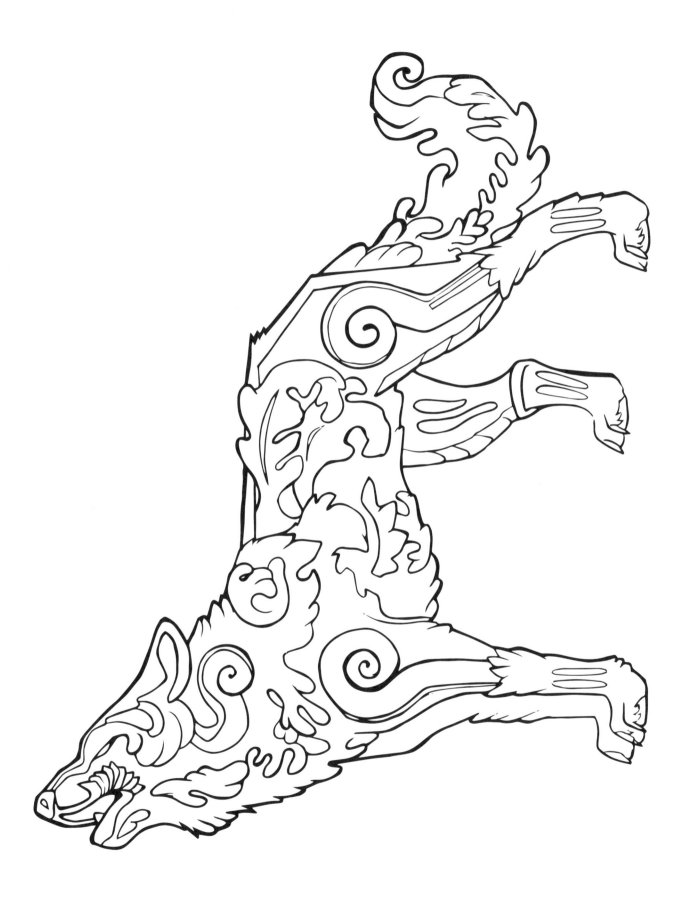

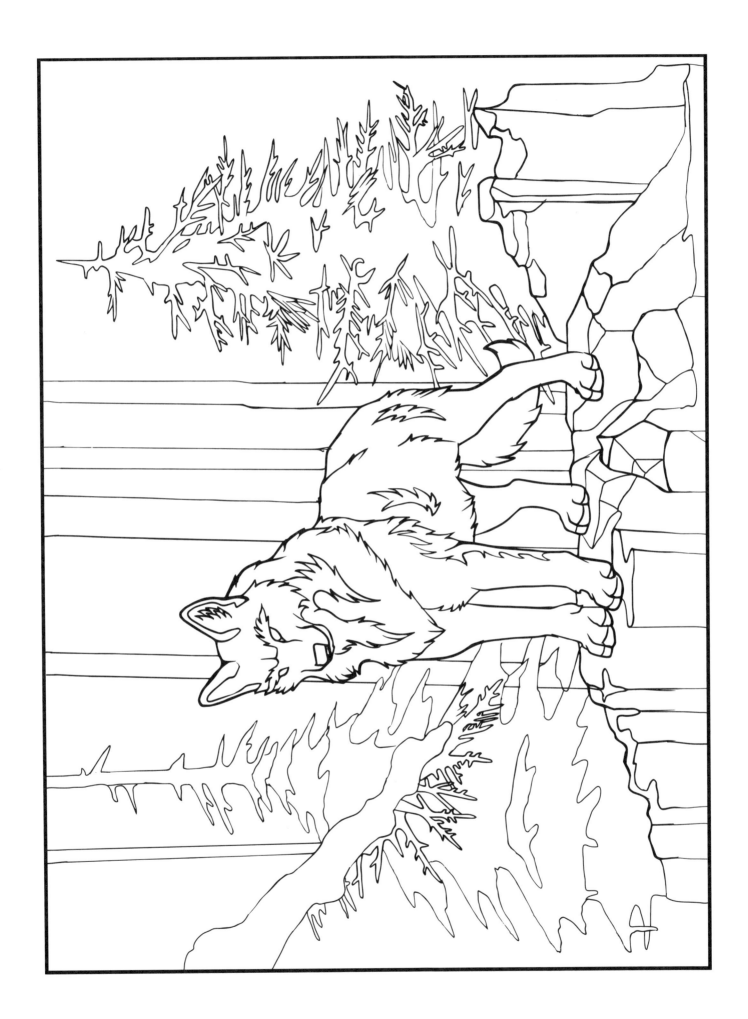

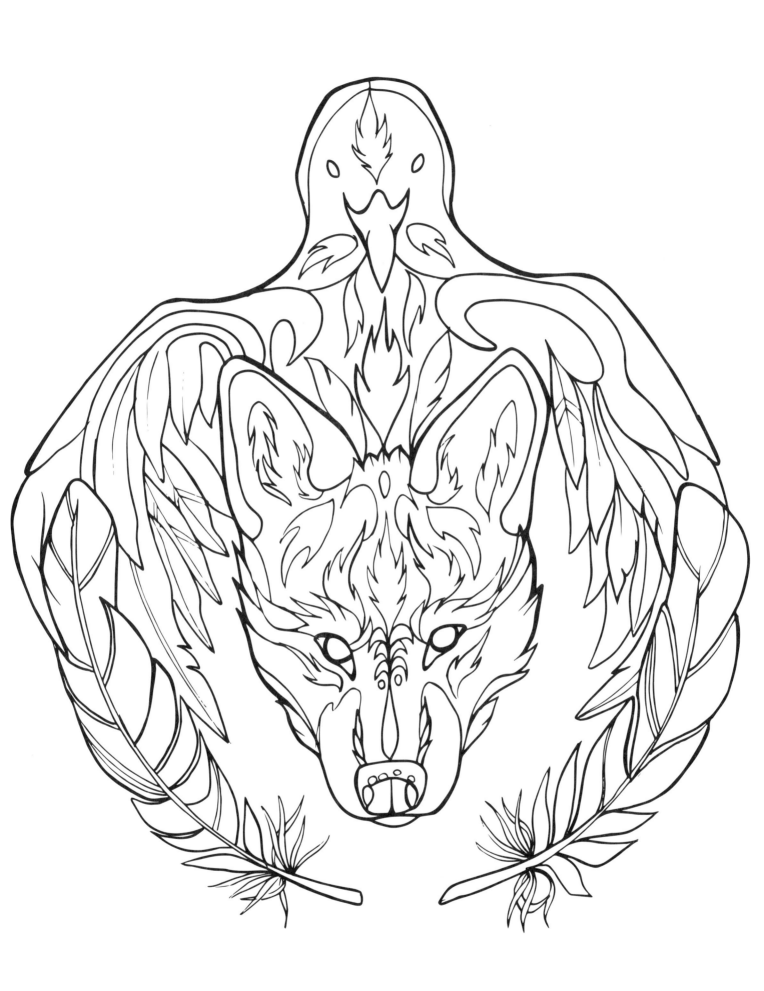

All stories are about wolves...Escaping from the wolves, fighting with wolves, capturing the wolves, taming the wolves, running with the wolf pack, turning into a wolf, and best of all, turning into the head wolf. No other decent stories exist.

MARGARET ATWOOD

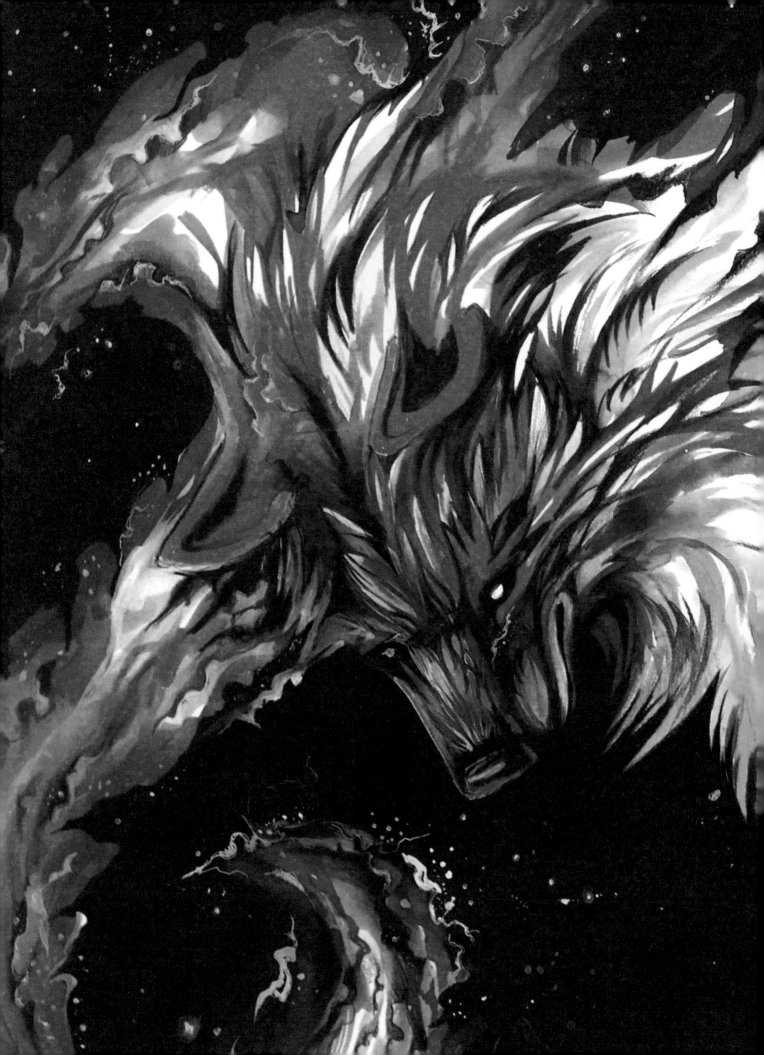

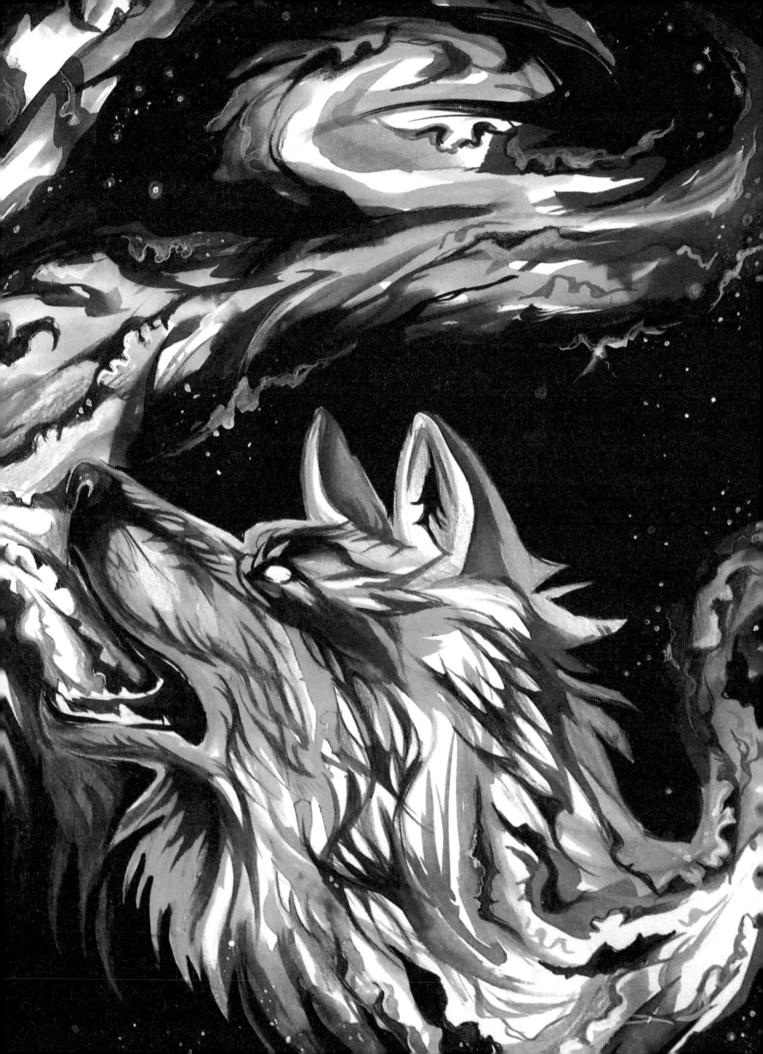

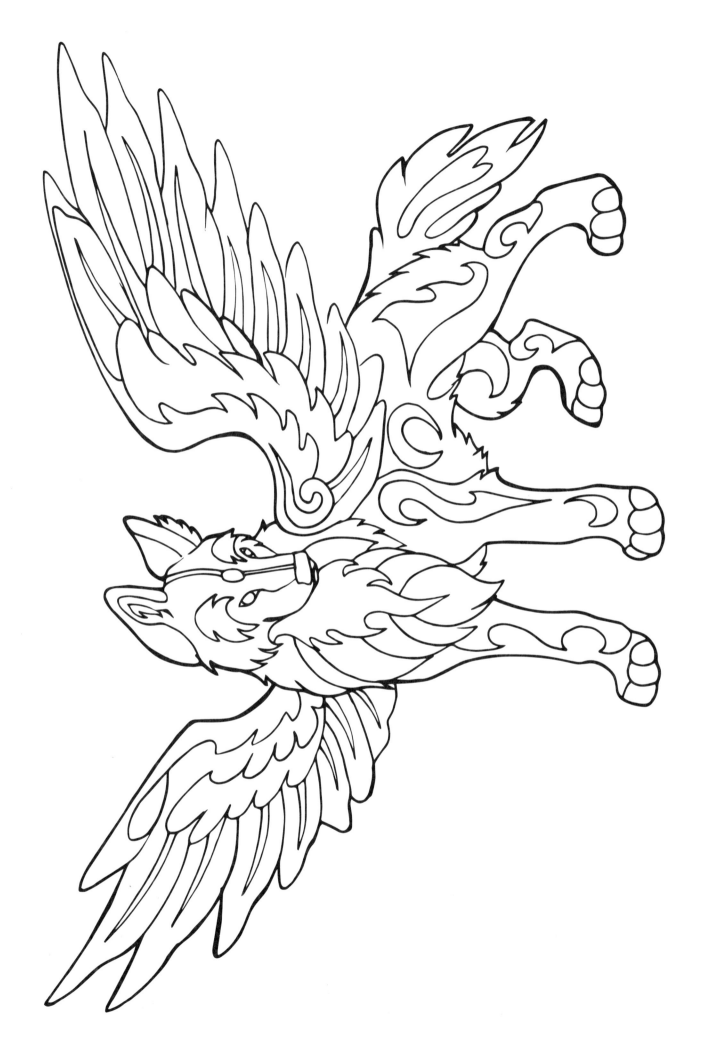

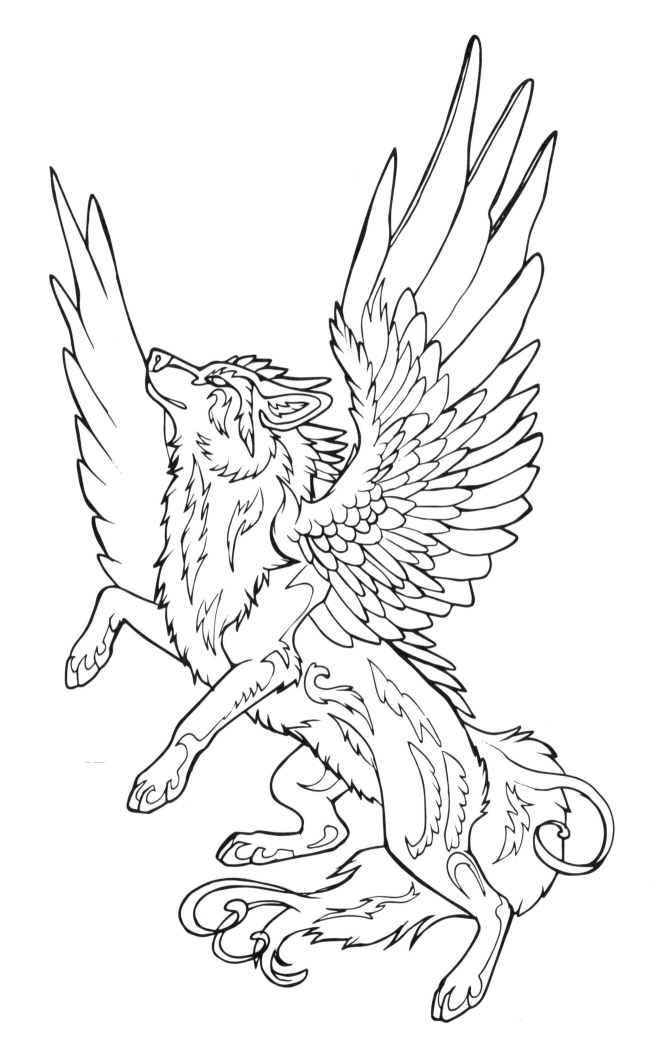

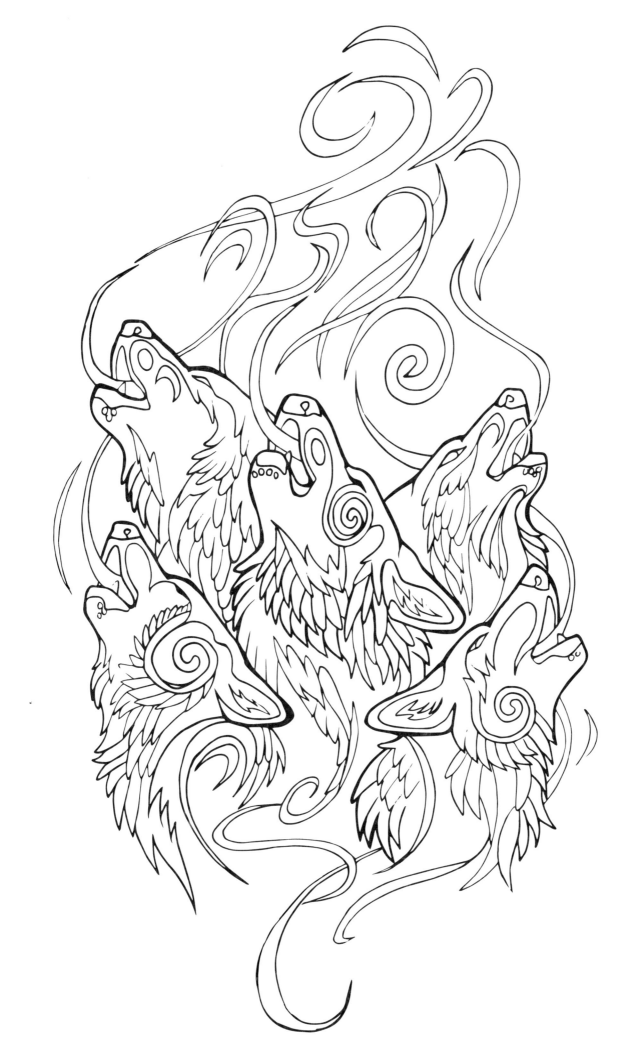

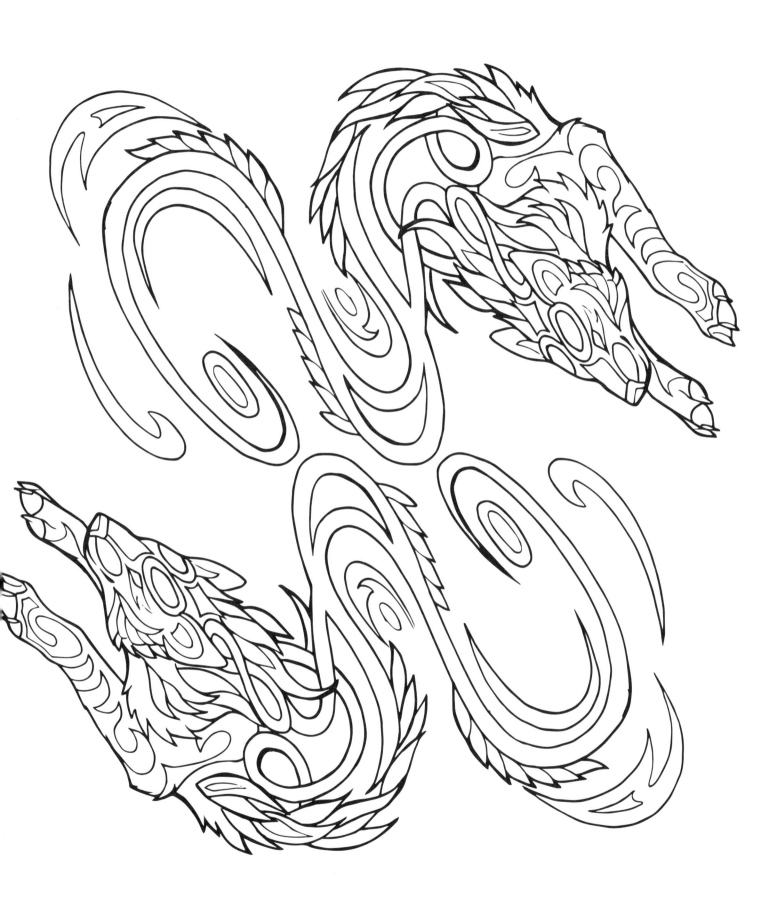

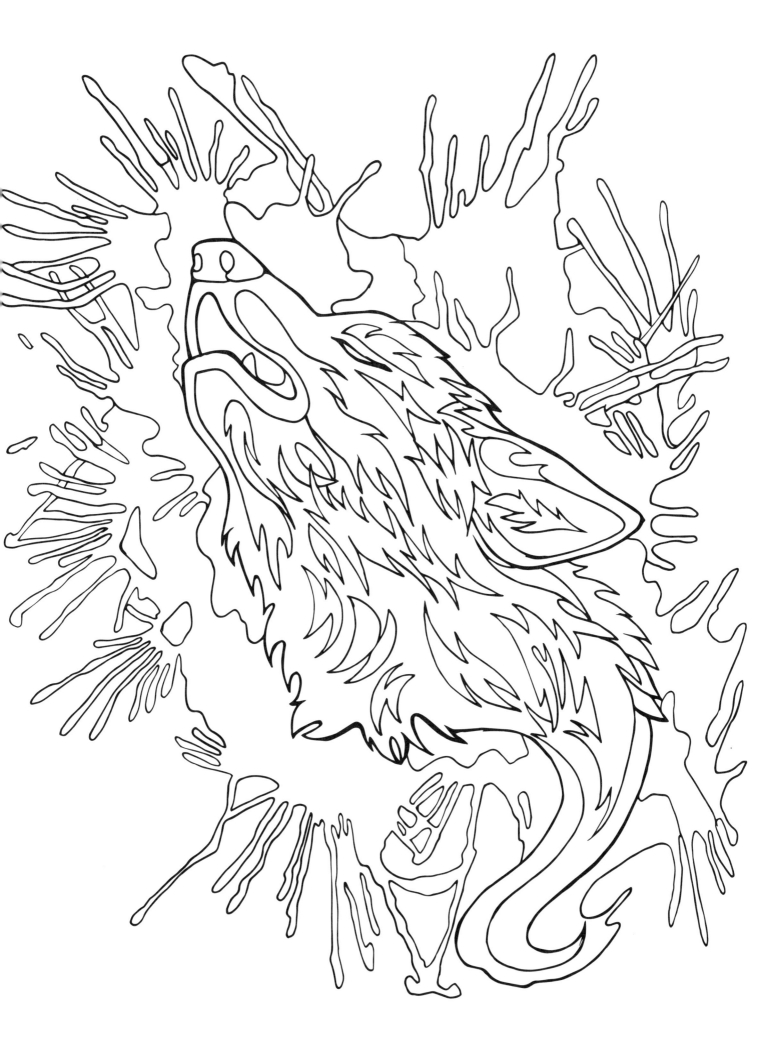

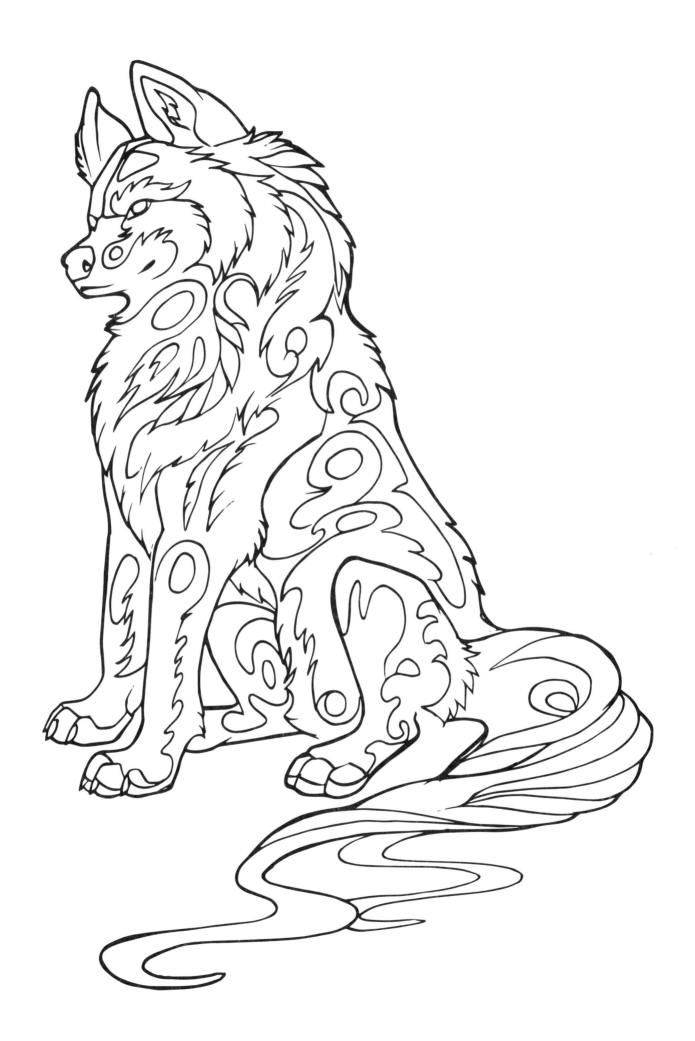

We listened for a voice crying in the wilderness, and we heard the jubilation of wolves.

DURWOOD L. ALLEN

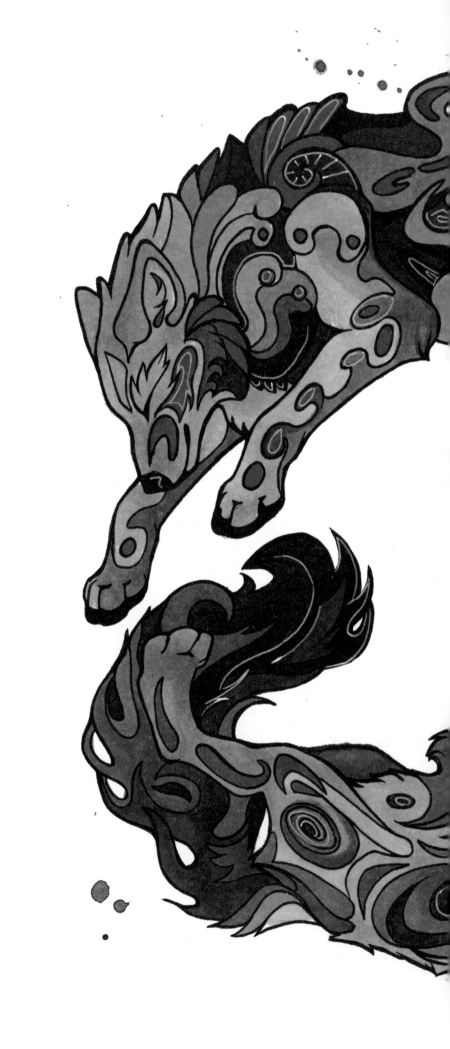

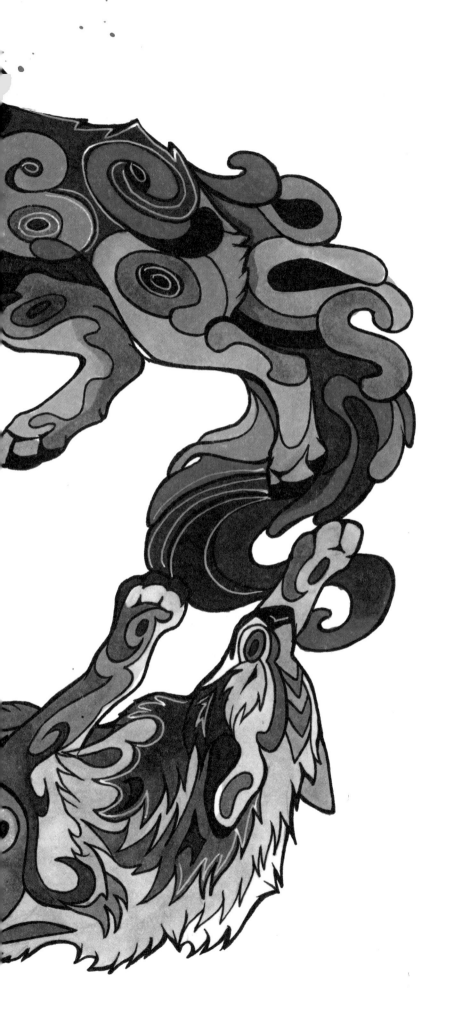

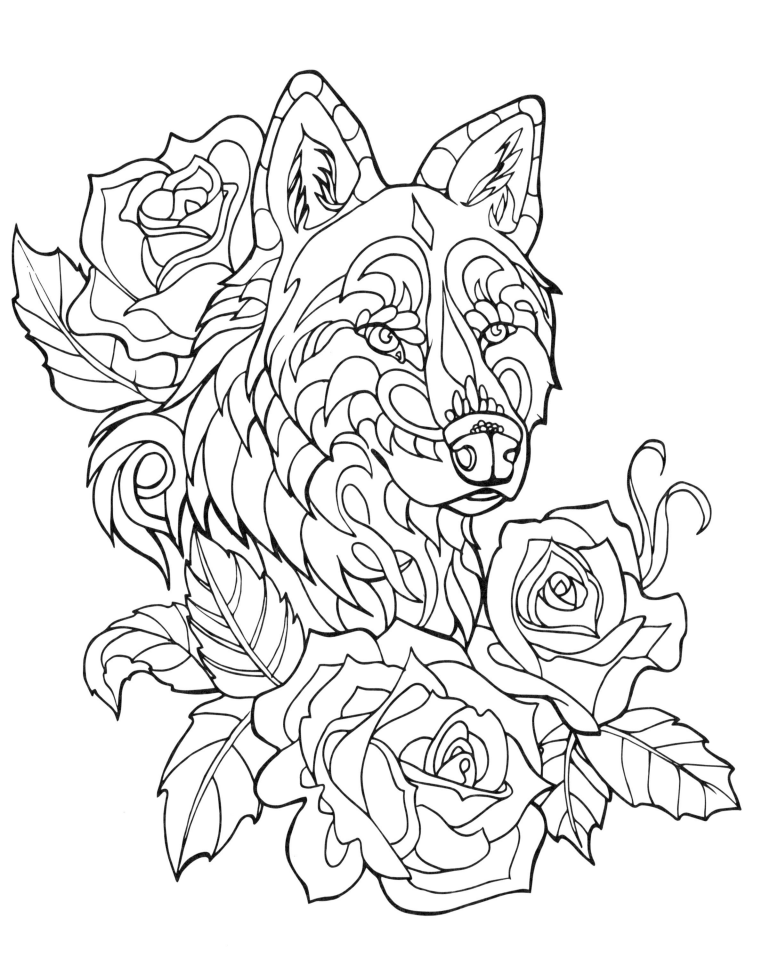

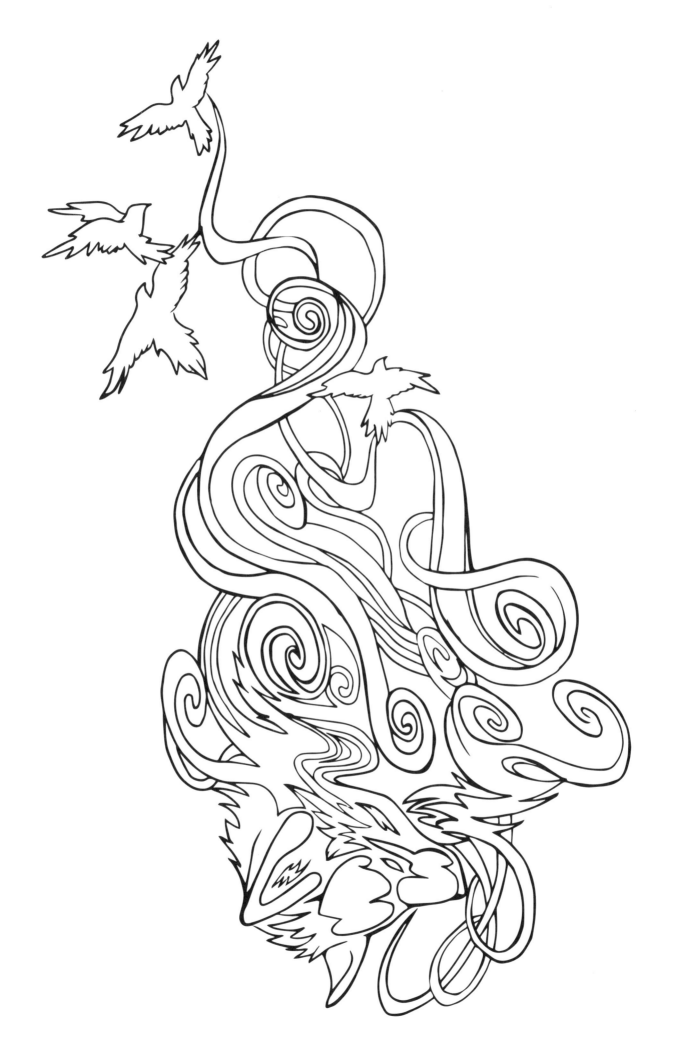

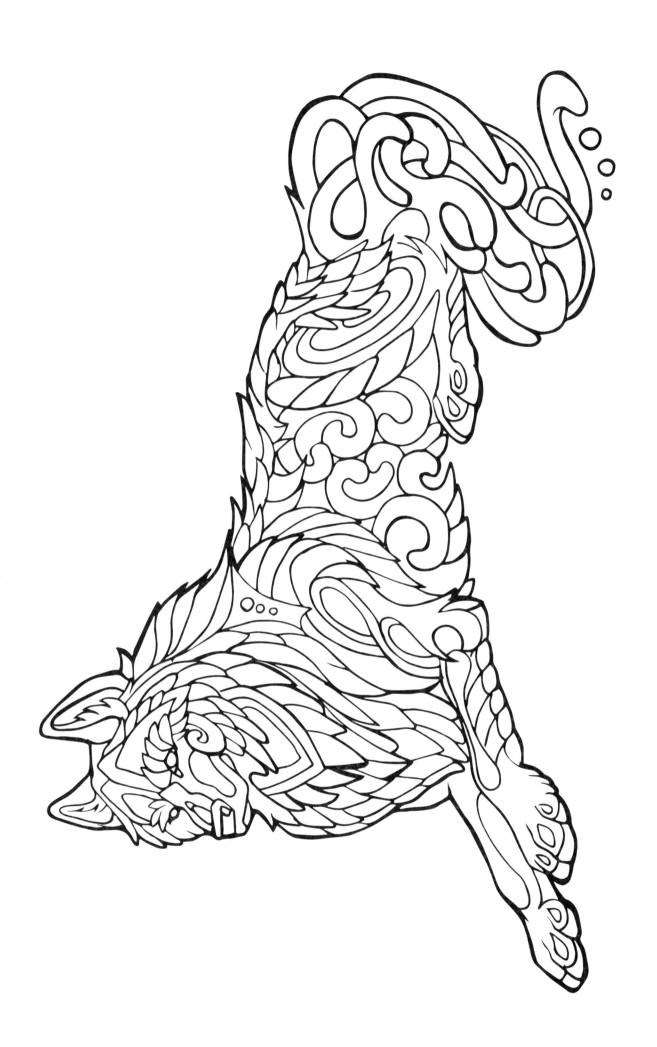

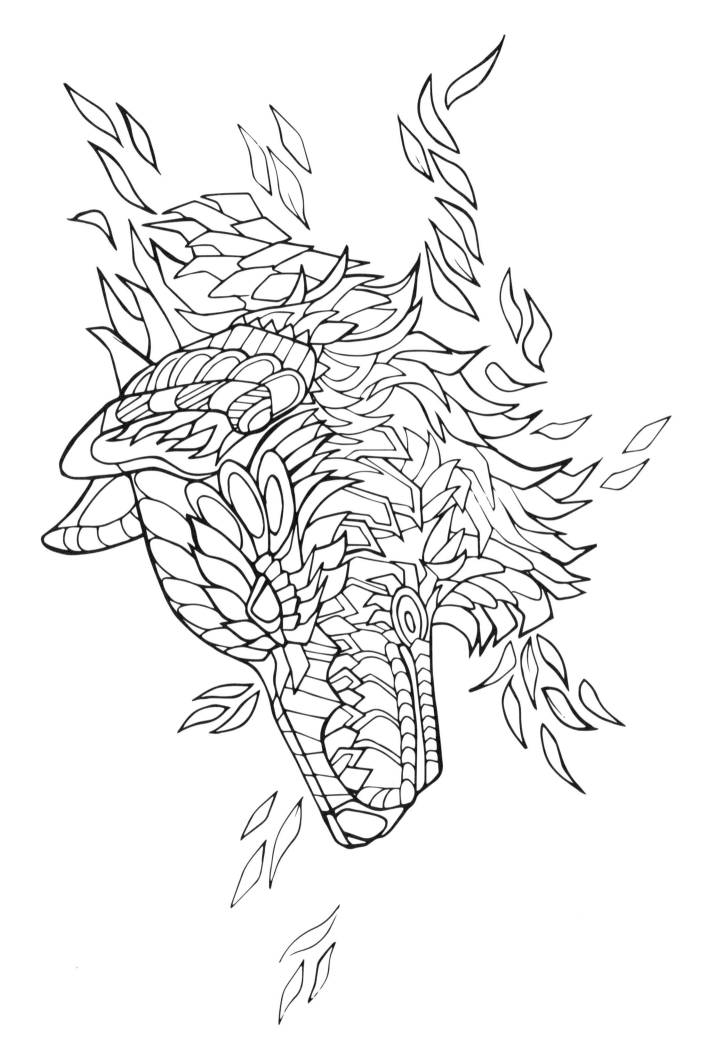

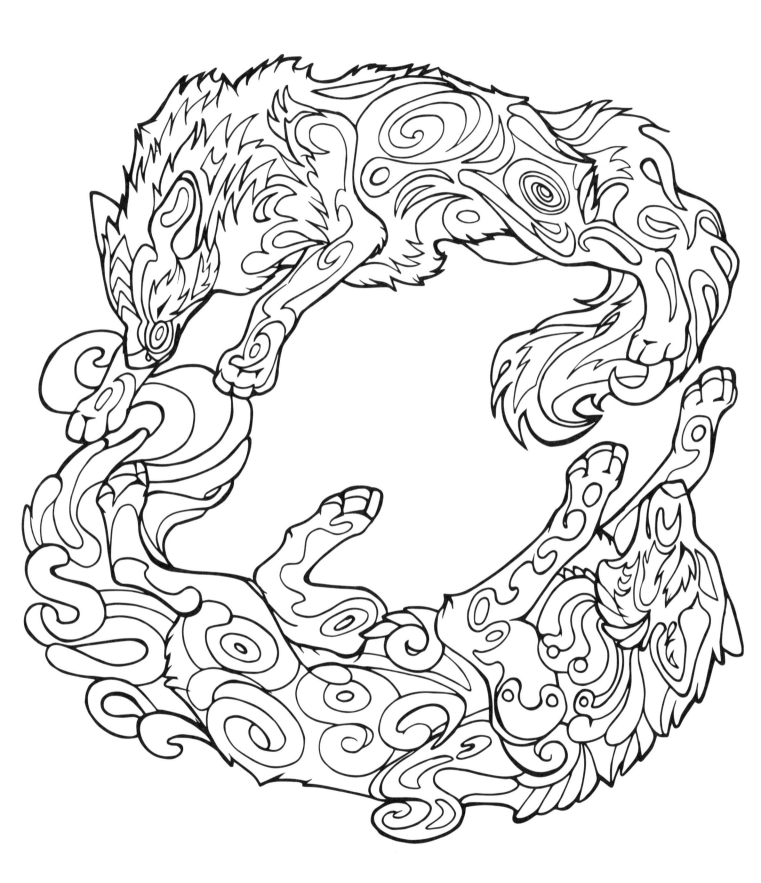

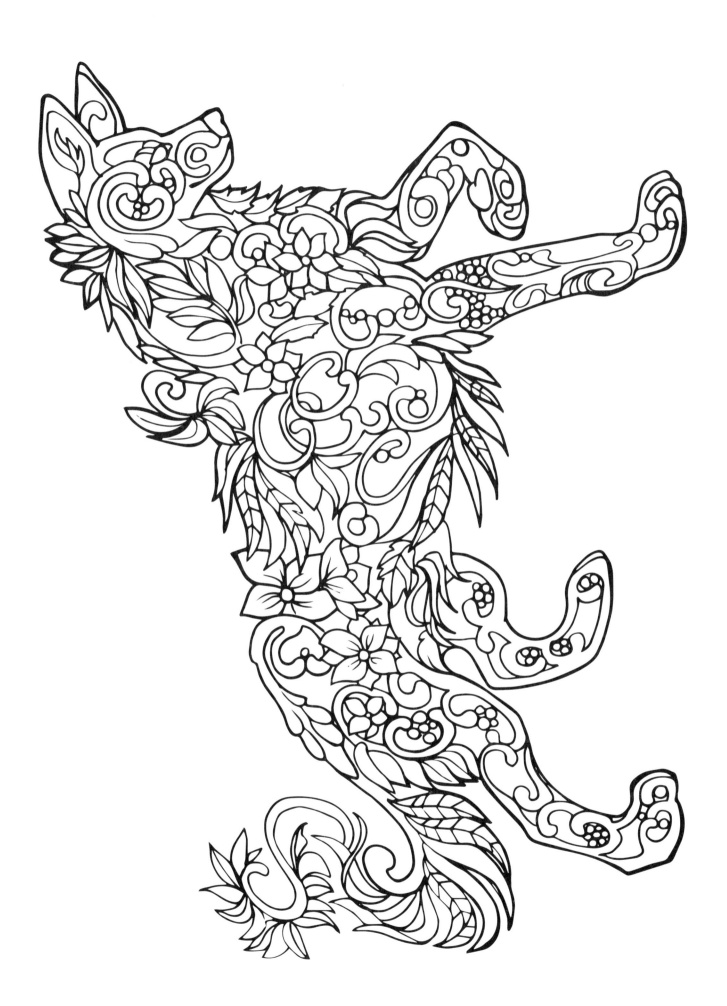

The roaring of lions, the howling of wolves, the raging of the stormy sea, and the destructive sword are portions of eternity too great for the eye of man.

WILLIAM BLAKE

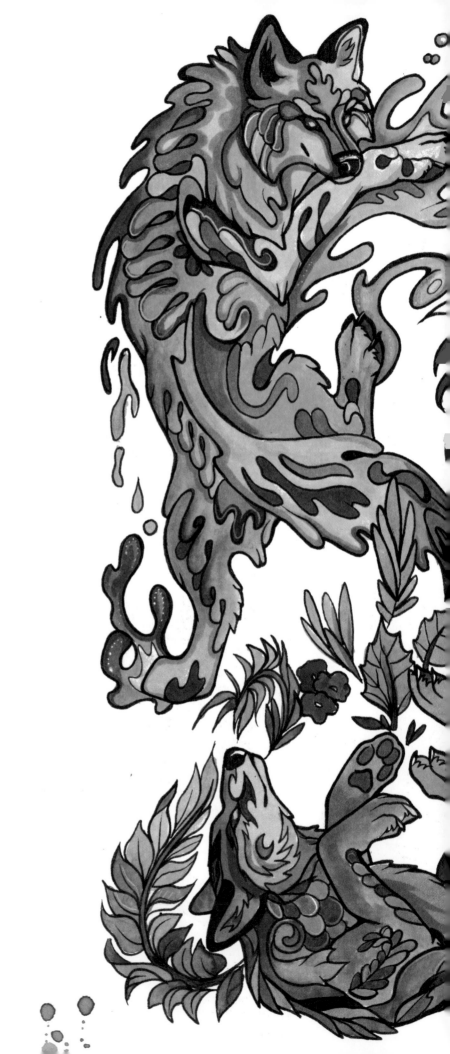

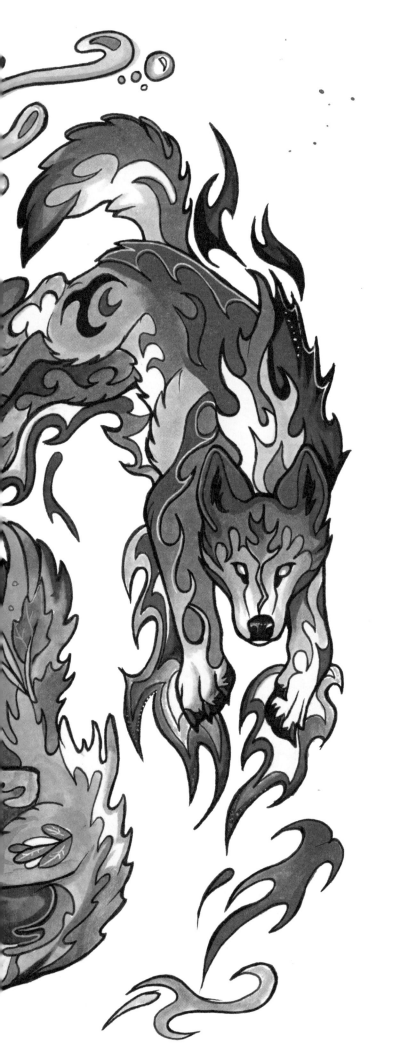

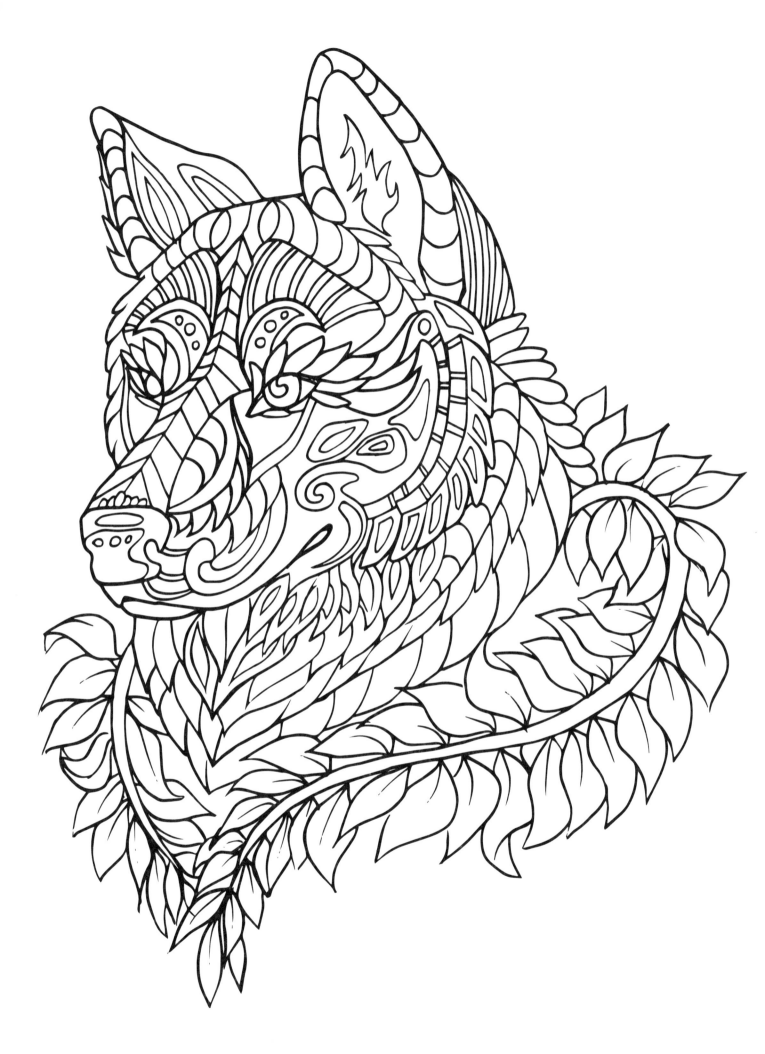

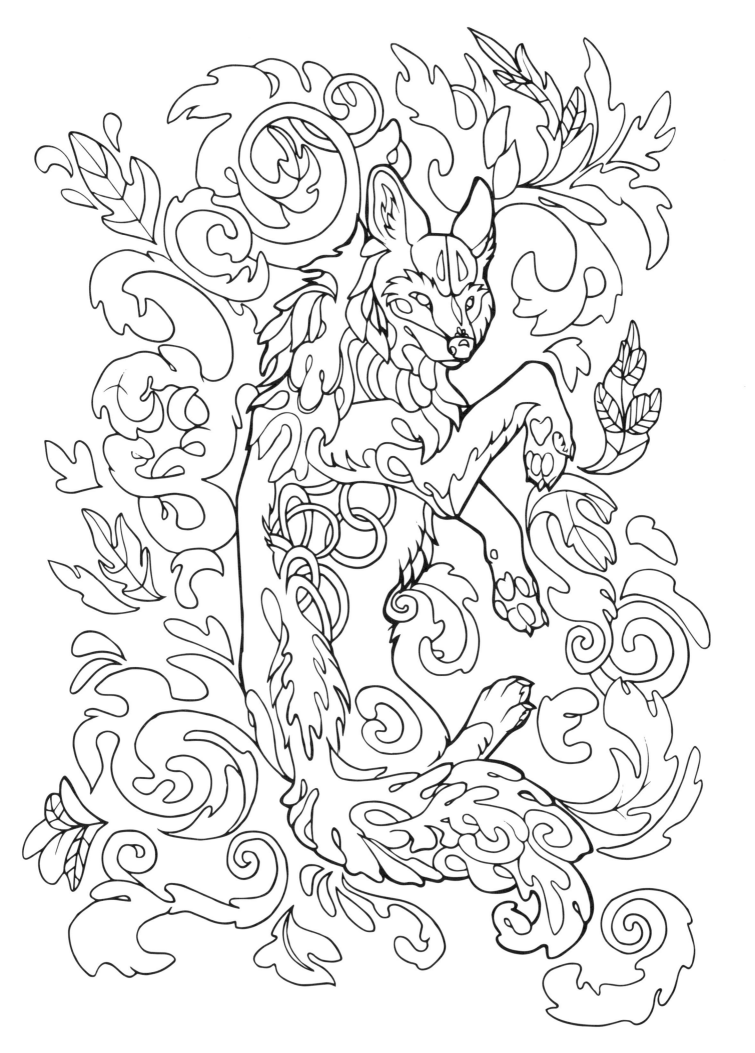

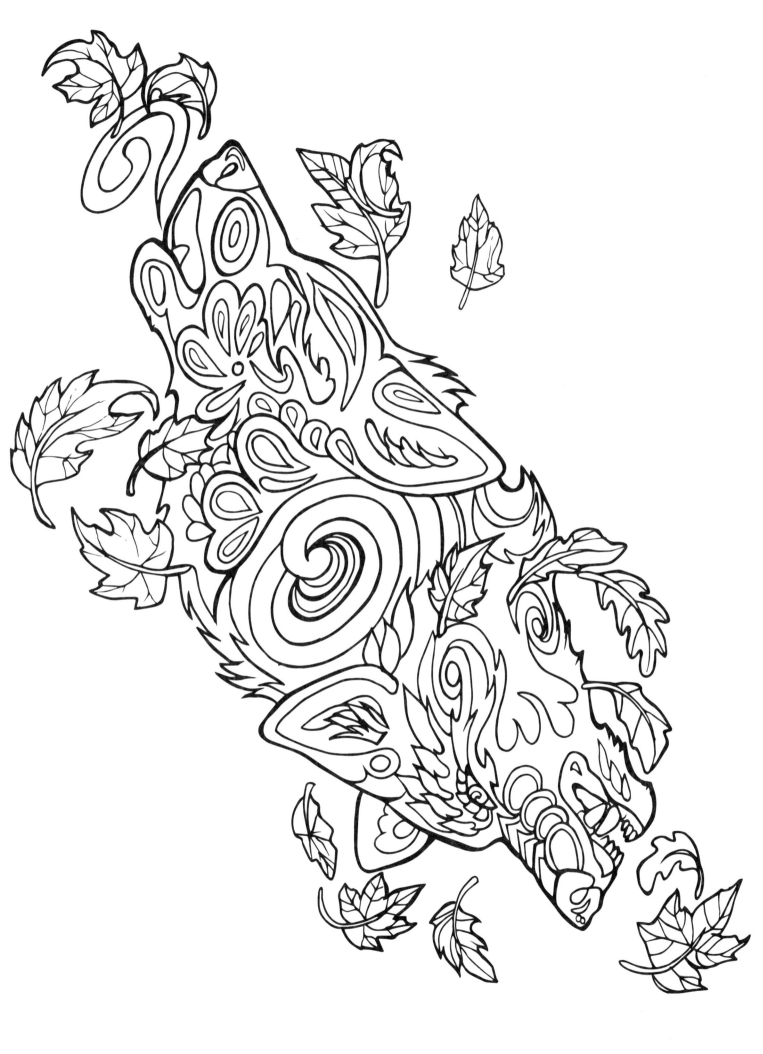

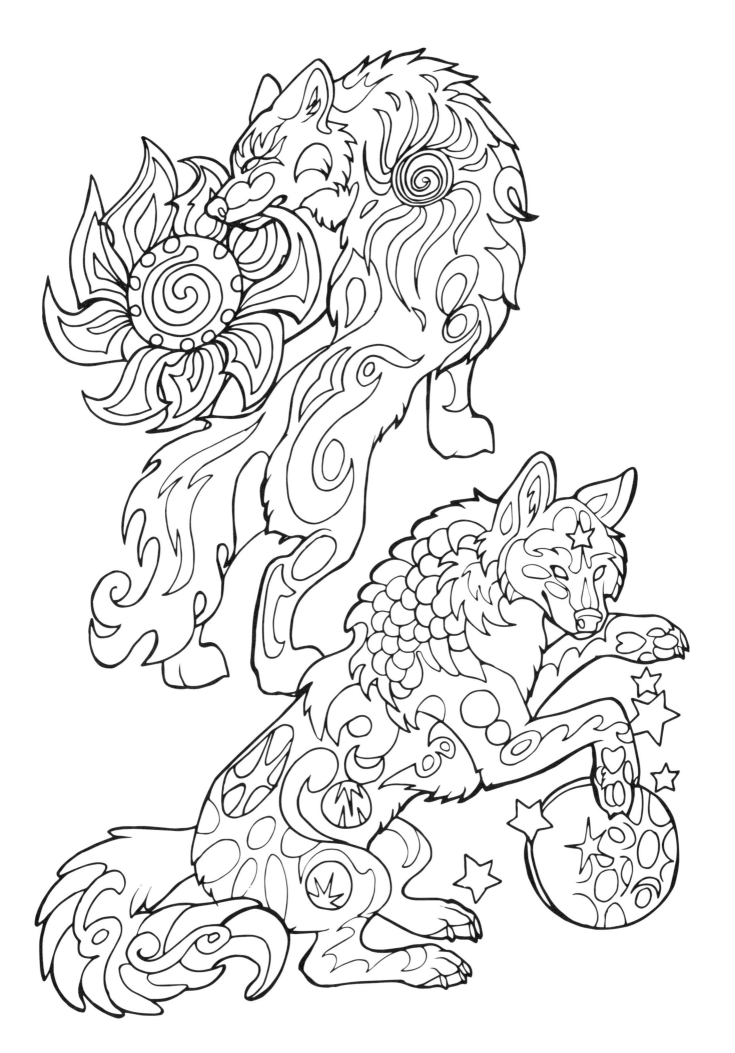

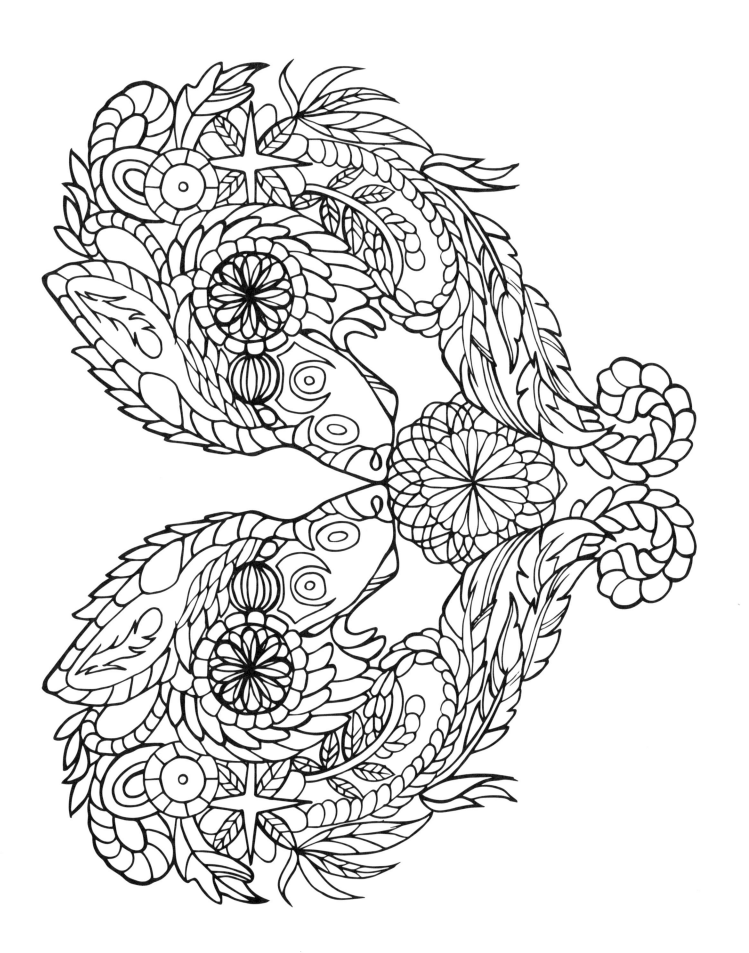

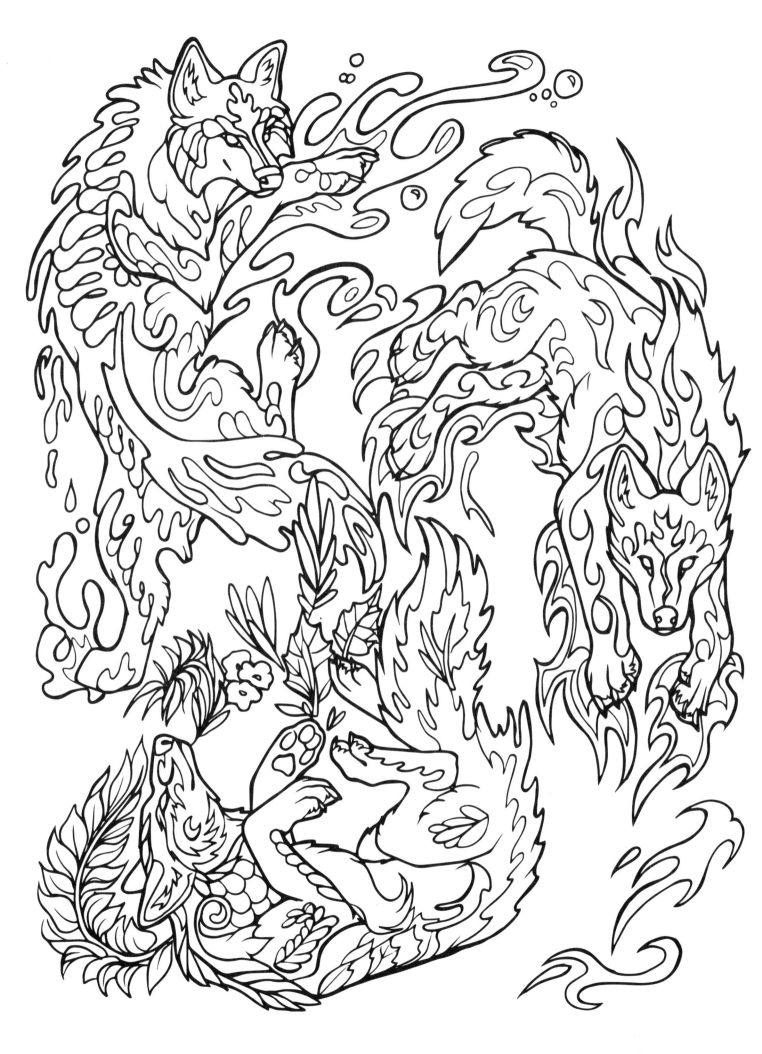

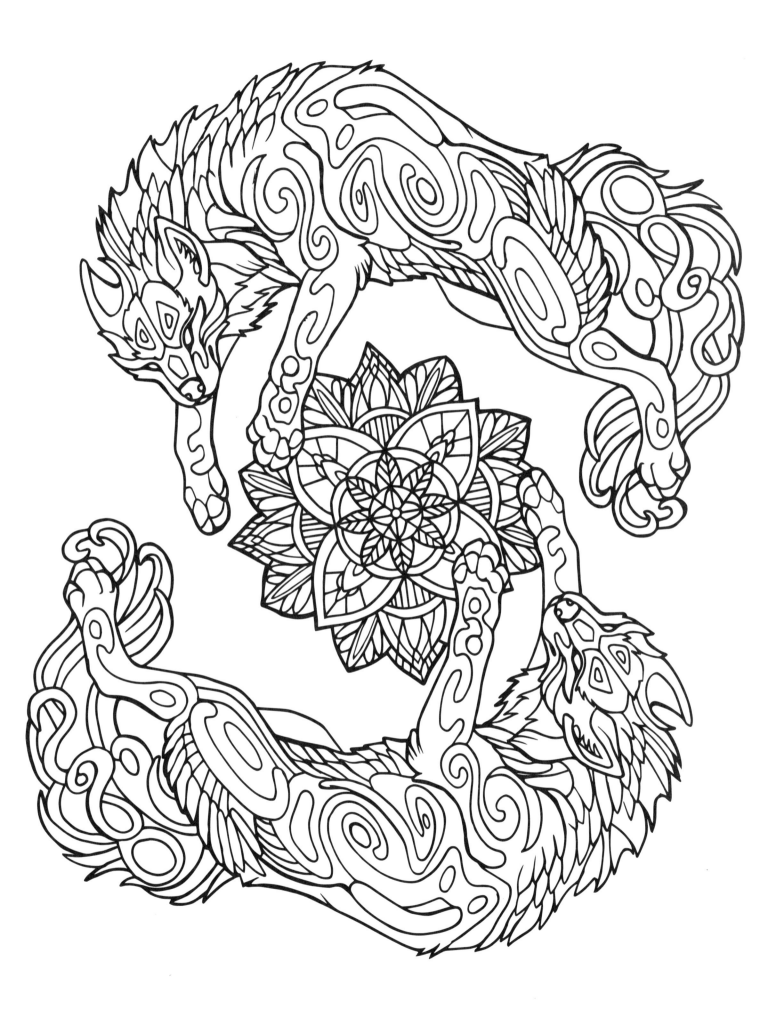

You were wild once. Don't let them tame you.

ISADORA DUNCAN

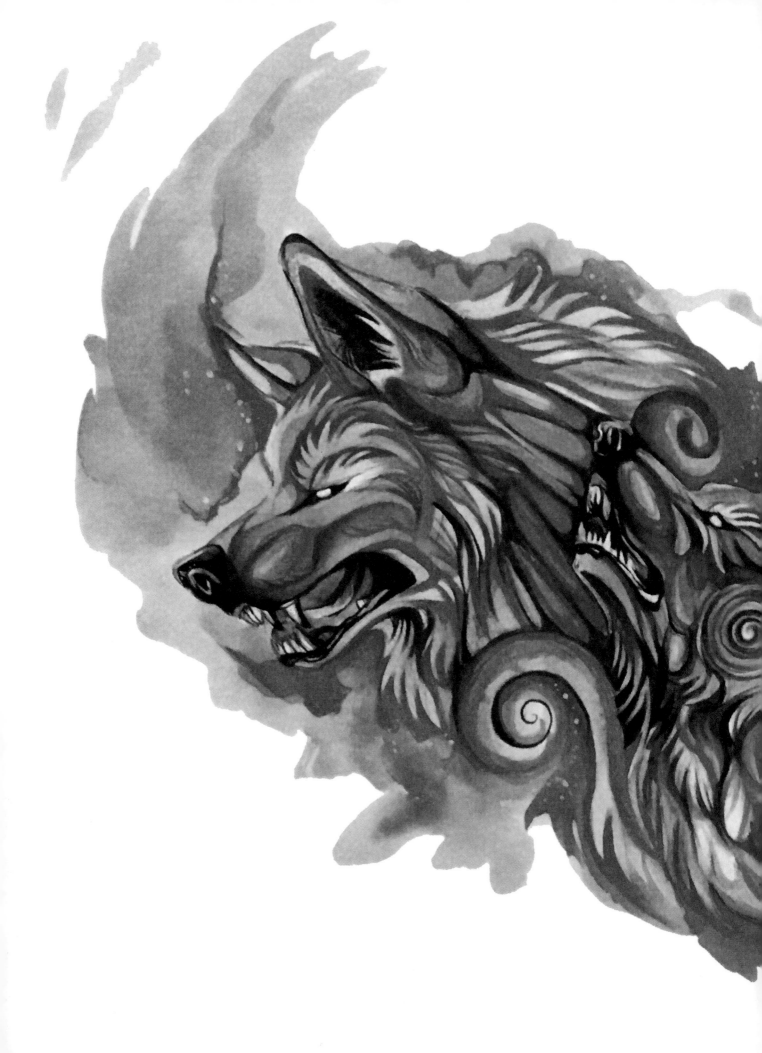

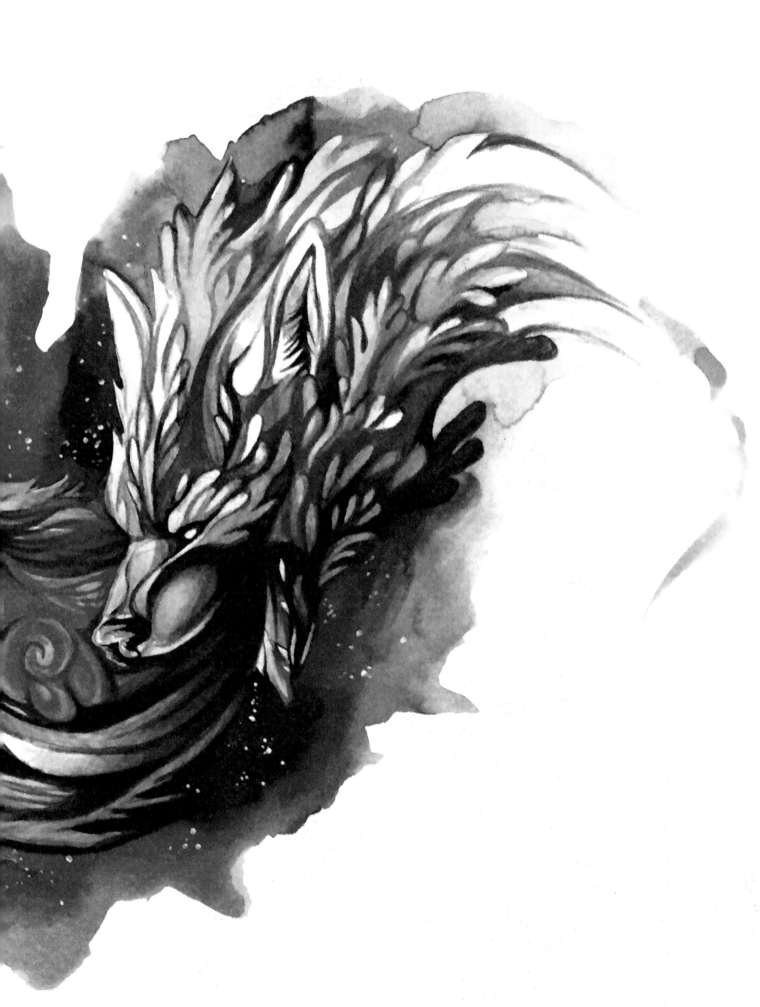

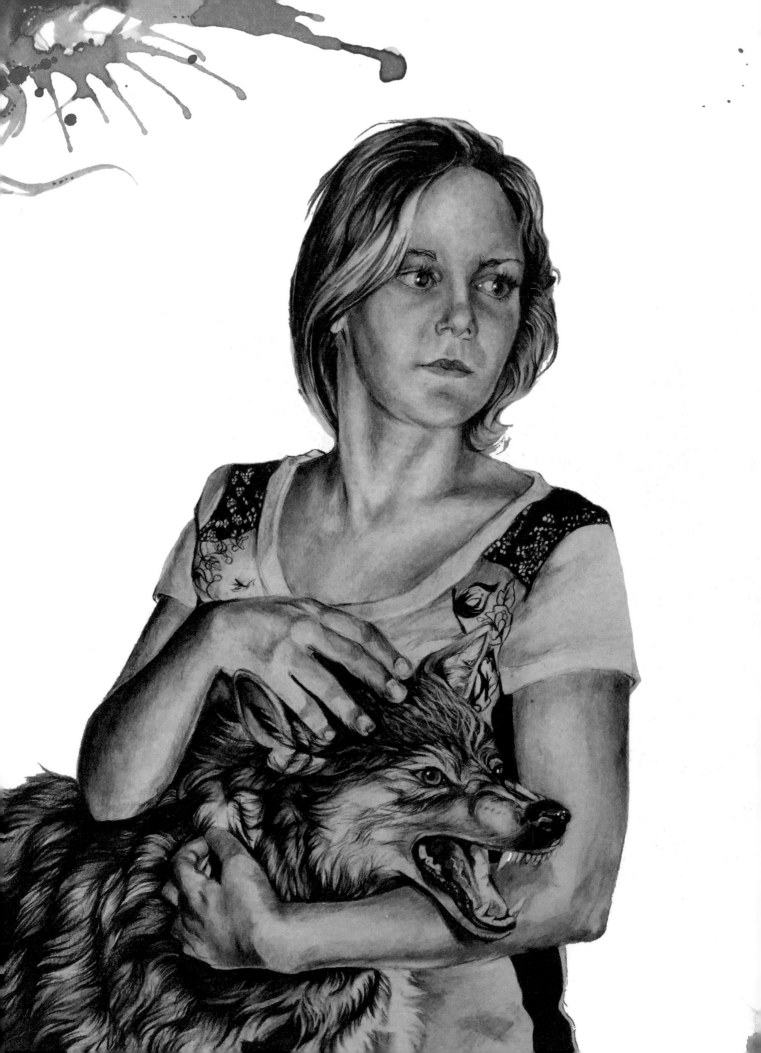